1 MONTH OF
FREE
READING

at
www.ForgottenBooks.com

By purchasing this book you are eligible for one month membership to ForgottenBooks.com, giving you unlimited access to our entire collection of over 1,000,000 titles via our web site and mobile apps.

To claim your free month visit:

www.forgottenbooks.com/free114148

ISBN 978-0-267-99151-8
PIBN 10114148

This book is a reproduction of an important historical work. Forgotten Books uses
state-of-the-art technology to digitally reconstruct the work, preserving the original format
whilst repairing imperfections present in the aged copy. In rare cases, an imperfection in
the original, such as a blemish or missing page, may be replicated in our edition. We do,
however, repair the vast majority of imperfections successfully; any imperfections that
remain are intentionally left to preserve the state of such historical works.

FACSIMILES OF ORIGINAL STUDIES

BY RAFFAELLE.

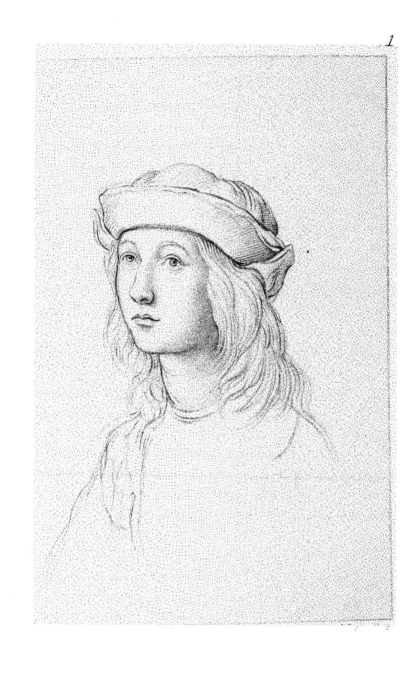

FACSIMILES OF, ORIGINAL STUDIES

BY RAFFAELLE,

IN THE UNIVERSITY GALLERIES, OXFORD.

ETCHED BY JOSEPH FISHER.

LONDON:

BELL AND DALDY, 186, FLEET STREET.

1865.

INTRODUCTION.

I N presenting to the public these etchings, from the designs of Raffaelle and Michael Angelo,* the publishers deem it desirable to give a brief sketch of their history, and of the evidence which may be adduced in favour of their authenticity. Perhaps in the annals of art a more remarkable record is not to be found. Collected by Sir Thomas Lawrence, and authenticated by his judgment and experience, they yet narrowly escaped a fate which at one time threatened to scatter them throughout Europe. Sir Thomas, convinced of the genuineness of these designs, and anxious to retain them in England, desired in his will that his collection should be offered to the Trustees of the National Gallery, at one third of its value. With the uncertainty which often accompanies the acts of official bodies, the offer was not accepted, and the whole series passed into the hands of Messrs. Woodburn. These gentlemen, after an exhibition which resulted in assuring art connoisseurs of the priceless value of these designs, opened

* For the convenience of purchasers the fac-similes from the drawings of Raffaelle are sold separately from those of M. Angelo, but the Introduction is attached to each volume.

negotiations with the Government, to whom they offered the entire collection for ten thousand guineas, a sum far below the estimate put upon it by an experienced and able judge. This negotiation failed, and an appeal was made to the public by the University of Oxford. Happily the University of Oxford, moved by some eminent men who appreciated the value of this unrivalled collection, set on foot a subscription among the members of the University. Seven thousand pounds were collected for the purchase, to which the late Earl of Eldon contributed the munificent sum of four thousand one hundred pounds.

Their earlier history is not less adventurous, and sufficient is known to trace them almost to their source. At least six of them belonged to Timoteo Della Vite, the friend and pupil of Raffaelle himself. From Della Vite they passed by inheritance to the Marchese Antaldi. Three of them are known to have come from M. Crozat. Three belonged to M. Mariette, the compiler of the catalogue of M. Crozat's collection, and author of a work of high authority on the general subject of design. Giorgio Vasari, a pupil of Raffaelle, and a great collector of his master's designs, the writer of the Lives of the Painters, was known to have been in possession of one of these sketches; and Count Zanetti, of Florence, an authority of no less eminence, a preserver and collector of everything curious or excellent in art, was the owner of another. Seven of them came from M. de Legoy, quoted by Landon in his Life and Works of Raffaelle as the possessor of that master's designs. Of our own countrymen, or those whom we may call by that name, King Charles I. possessed one, the Earl of Arundel two, Dr. Mead one, and Consul Udney, of Venice, two. Sir Peter Lely was the owner of three of them, Mr. Jonathan Richardson held four, Sir Joshua Reynolds eight, Benjamin West one, Fuseli one, and Richard Cosway three.

Like many other famous works of art, a portion of these drawings shared in the vicissitudes of the French Revolution, ultimately, however, to be landed under the safe keeping of England. The French armies, as is well known, were accompanied by persons appointed to select and carry off the best pictures from the palaces, churches, and galleries, public or private, in places occupied by the soldiers of the Republic. They were furnished with authentic catalogues of the best pictures, and many interesting stories are told of the treasures they were appointed to "convey." Marshal Soult was accustomed to point to a gem which he specially valued, because it "saved the life of a Spanish noble." The *modus operandi* was somewhat peculiar. The marshal was determined to possess the picture; the noble, equally desirous to retain it, hid it, and declared he had not got it. The marshal, "master of the situation," ordered its quondam possessor to be shot, unless the picture was produced within a given time, and of course the production of it "saved his life." The existence of the designs of Raffaelle and of Michael Angelo was not generally known, and hence they were not included in the catalogues furnished to the French collectors. The Chevalier Vicar, who was sent to Italy by the French Government, nevertheless selected the most choice drawings wherever he found them, (whether or not they were enumerated,) and those not named in his commission he retained for his own study. Amongst them were many of the designs which now furnish the subjects of these etchings.

The collection of the Chevalier Vicar, one of the most valuable known in modern times, appears to have been divided into two portions, both of which fortunately fell into English hands. One of them the Chevalier entrusted to a friend in Florence, from whom it was purchased by Mr. W. Y. Ottley. The other was retained by the Chevalier himself, in Rome, where he was visited by Mr. S.

Woodburn, in 1823. Mr. Woodburn opened a negotiation for the purchase of the Chevalier's collection, and the M. Vicar was tempted by the offer of eleven thousand Roman scudi. The transfer of these treasures was duly reported in the *Diario di Roma*, and great interest was created in consequence. The public for the first time became aware of their existence in a collected form, and an offer was made to Mr. Woodburn from Russia, which he patriotically declined, determining to keep them for his own country. A singular incident at the sale of these drawings of the Chevalier Vicar revealed the existence of other treasures of remarkable interest and value. Mr. Woodburn discovered that some designs by Raffaelle remained in the keeping of the Marquis Antaldi of Pesaro, the name of whose ancestor is mentioned above, and he resolved to endeavour to secure these important relics. Accordingly, he set out for Pesaro, where his perseverance was rewarded by a view of these interesting remains of art history. He found there a portrait of Timoteo Della Vite, a scholar of Raffaelle, and his executor. This is said to be the finest head ever produced in black chalk. Besides this most valuable prize, were some admirable drawings, and on the back of two of them were found studies for sonnets. This historical evidence, if other things were wanting, is beyond all question of the highest value. The Marquis of Antaldi was a descendant of Timoteo Della Vite, the friend and pupil of Raffaelle, and these drawings had never been out of his family. Hence, in addition to the artistic testimony which is marked upon these productions we have historical evidence of a character which is almost incontrovertible. The studies for sonnets on the back of two of the drawings of course add materially to their interesting character.

The visit of Mr. Woodburn to the Marquis Antaldi was, however, not only useful in securing this small though admirable collection, but it also opened another channel of investigation and

research, and was the means of bringing to England another collection of the designs of Raffaelle and Michael Angelo. After the negotiation between the Marquis Antaldi and Mr. Woodburn was completed, the former presented his visitor with a curious manuscript catalogue of pictures and drawings; this catalogue is now in the University Galleries. From this source it was discovered that M. Crozat had purchased, about the year 1680, many of the Raffaelle drawings from the ancestor of the Marquis Antaldi. Here was another link in the chain of discovery, and, fortunately, Mr. Woodburn was able to work it out, through a very happy incident. The Marquis Legoy, who lived in Paris about the year 1820, was desirous of securing a cabinet of Greek coins which had been sent from Naples to Paris for sale. His means would not allow him to become the purchaser, and he therefore offered for sale his collection of drawings, in order to secure possession of the coins. As soon as Mr. Woodburn heard of the circumstance, he set off from Amsterdam in the depth of winter, and bought the entire collection of drawings from the Marquis. The collection contained only 138 drawings, but they were of the highest quality, and the whole of them were purchased by Mr. Thomas Dimsdale, on the very day Mr. Woodburn came from Paris. This was two years before the interview with the Chevalier Vicar or the Marquis Antaldi, though the importance of the purchase from M. Legoy was not fully known till the last event. In the manuscript catalogue handed by Antaldi to Mr. Woodburn, it was shown, that many of these drawings transferred by M. Legoy were those which were sold 140 years before by a former Antaldi to M. Crozat. Thus it seemed as if nothing more were wanting to complete the documentary evidence of their genuineness. The Chevalier Vicar gathered them from the best galleries in Italy, and verified their authenticity by his knowledge, taste, and research. The Chevalier sold them to Mr. Woodburn,

and introduced the purchaser to the Marquis Antaldi, who was a lineal descendant of the executor of Raffaelle, as well as an enthusiastic collector of his drawings, and from him they secured a further identification. Again, by means of a manuscript catalogue of undoubted antiquity, a few more of the drawings were found in Paris, their possessor in the French capital being able to trace their history in a direct line from M. Crozat, the friend of the predecessor of the Marquis Antaldi.

It is now easy to follow them to their present position. Mr. Woodburn, in his indefatigable researches after the drawings of Michael Angelo and Raffaelle, appears to have acted principally as the agent of Mr. Dimsdale and Sir Thomas Lawrence. It was Mr. Dimsdale who purchased the Legoy collection; it was he who bought the Vicar treasures; whilst Sir Thomas, whose purse was not so deep as that of his rival, occasionally bought single selected specimens. He was able, subsequently, to purchase the whole Florentine selection of the Chevalier Vicar from Mr. Ottley for ten thousand pounds. Of the designs, however, from which our etchings are taken, eight passed from Mr. Dimsdale's cabinet during his lifetime into that of Sir Thomas Lawrence. Five came from the gallery of Mr. Joseph Harman, four from that of Lord Hampden, two from Earl Spencer's cabinet, two from that of Mr. Duroveray, one from that of Mr. Hugford, others from Mr. Berwick, eighteen from foreign connoisseurs, and one was presented to Sir Thomas by the Duke of Devonshire. This drawing bears on the back of it, in the duke's handwriting, the record of the presentation. It was, however, from Mr. Dimsdale's collection that the majority of these treasures were obtained. The "ruling passion" was never, perhaps, more strongly exhibited than in the case of this gentleman. During a severe illness, and only a few days before his death, he gave three thousand guineas for the Raffaelle and Michael Angelo drawings from the Roman collection of M. Vicar.

Very shortly after his death the entire Series of his Italian drawings were purchased by Sir Thomas Lawrence for the sum of five thousand five hundred guineas. This addition made the cabinet of Sir Thomas the finest in existence. An amusing anecdote is told of the two distinguished collectors, which will bear repetition here. Sir Thomas, not anticipating the serious illness of Mr. Dimsdale, was most anxious to obtain from him, by means of money, exchange, or any other mode, the possession of the best drawings in the Vicar collection. He pressed his purpose through Mr. Woodburn, their common friend, but without avail. One day during Mr. Dimsdale's illness, a servant of Sir Thomas's arrived to inquire after his health, and to beg his acceptance of a brace of pheasants. " Ah," said Mr. Dimsdale, who was at that time very ill, " these pheasants smell very strongly of Raffaelle and Michael Angelo." However, Sir Thomas had not long to wait, for, a few days after, this liberal and distinguished amateur died.

With respect to their genuineness there is abundant proof, external and internal; in the approval of the most famous artists and connoisseurs, amongst whom the name of Sir Thomas Lawrence stands pre-eminent; in the anxiety of the Royal Academy to secure possession of them; in the memorial of between three and four hundred amateurs and professors of art to retain them in England; in the pride with which they are regarded by the University of Oxford, and the liberality which that distinguished body showed in the purchase of them. So convinced was William IV. of their great merit that he gave a donation of fifty guineas to secure the gratuitous admission of students of the Royal Academy to these designs. In an elaborate paper, the late Rev. Vaughan Thomas proved their authenticity, not only from the evidence of reputation and the concurrence of opinions and authorities, but from the peculiarities of workmanship, drawing, lines of contour and lines of shading; from the materials with which

Raffaelle worked; from the painter's known manner of expressing his thoughts and feelings; from the changes which are known to have taken place in Raffaelle's manner; from the known facts in the history of his practice as a painter; from his known study of the antique, and from his earnest desire that his figures should be anatomically correct. What is said for Raffaelle may of course be also said for Michael Angelo. It is not our intention to follow the arguments of Mr. Thomas, but we may refer to one or two points of singular interest. On the back of one design— "Various Studies for the celebrated School of Athens"—is to be found the study for a sonnet, in the handwriting of Raffaelle. We find the last word in each intended line jotted down, as if he had fitted his ideas to his rhymes, and made the sense subservient to the sound. This is an interesting literary memorial, and in itself is a valuable corroborative piece of testimony. Again, there is a drawing of the Annunciation, which is pricked with a needle on the outline, for the purpose of tracing on the panel. Again, in a study for the Borghese entombment we have the figures of the three Apostles undraped to mark the anatomy, and the body of the Saviour indicated in red chalk. In the drawings of Michael Angelo similar interesting memorials of his care to give effective form to his conceptions, are to be found. At the back of one sheet of studies, apparently designed for a pupil, is to be found a sonnet by the great master himself. On the reverse of another may be seen studies of eyes and a head, which a pupil of Angelo's, Andria Mini, copying them indifferently, his master has written an observation, recommending perseverance to him. On the reverse of another are a few anatomical studies; on the back of another are verses in the handwriting of the master; on another, remarks respecting his accounts. Two other sheets are made up of four leaves from Michael Angelo's pocket-book; they are slight sketches from nature, in pen and black chalk. Two other sheets

are made up of four leaves from M. Angelo's pocket-book, with pen sketches, and several of them bear the autograph of the great master.

These, of course, are incidents which add only to the historical interest of these drawings, not to their artistic merit. That must be left to the judgment of the amateur and professor, and it may be said, that no one can view them without being convinced of their transcendent merit. As Mr. Thomas remarks of the Raffaelle collection, they trace, in an unbroken series, " the practice in art of this prince of painters; " and so, it may be added, of Michael Angelo, the king of artists. There is no room to doubt the priceless character of these productions, and the University of Oxford deserves the thanks of the nation for the part it has taken in their preservation. The publishers hope, in the present volumes, to extend the usefulness of this magnificent collection, and they confidently offer the etchings of Mr. Joseph Fisher, of Oxford, as careful, spirited, and thoroughly characteristic reproductions.

STUDIES BY RAFFAELLE.

1483—1520.

Rafaello Sanpie

I.

PORTRAIT OF RAFFAELLE—when young; showing the great skill with which he drew at an early period. This beautiful and interesting drawing, executed in black chalk and heightened with white, has been copied in Mr. Passevant's Life of Raffaelle, where it is described.

> Size, 15⅛ in. by 10½ in. From the Collections of the Chevalier Vicar, W. Y. Ottley, Esq., and J. Harman, Esq.

II.

OUR SAVIOUR AND THE WOMAN AT THE WELL—a most beautiful pen drawing of the Perugino period.

> Size, 14¾ in. by 9⅛ in. From the Collections of W. Y. Ottley, Esq., and Robt. Udney, Esq.

III.

STUDY OF A YOUNG MAN—drawn at an early period—on the reverse is the other figure engraved.

> Size, 12 in. by 7½ in. From the Collection of the Duke of Alva.

IV.

HEAD OF AN ANGEL—pen drawing.

Size of the original. From the Collection of Prince Borghese.

V.—VI.

TWO SMALL LANDSCAPES—pen drawings.

From the Collections of Vasari, M. Crozat, and the Count de Fries.

VII.

SMALL DRAWING OF A WOMAN SUCKLING A CHILD—in bistre.

Size, 5⅜ in. by 4½ in. From the Collection of the Duke of Alva.

VIII.—IX.

STUDIES—heads and hands, &c. ; drawn with a metal point, heightened with white, on prepared paper, during his visit to Florence, as is proved by a small light sketch of the celebrated *Fighting for the Standard* of L. da Vinci, which then existed in that city. This Study is in the highest preservation. The profile head resembles Fra Bartolemo.

Size, 10¾ in. by 8½ in. From the Collections of W. Y. Ottley, Esq., F. J. Duroveray, Esq., and T. Dimsdale, Esq.

X.

INFANT JESUS—pen drawing.

Size of the original. From the Collection of the Marquis Legoy.

XI.

STUDIES FOR THE SUBJECT OF THE VIRGIN, INFANT CHRIST, AND ST. JOHN—figures unclothed.

Size, 10 in. by 8⅝ in. From the Collection of Mr. Josi, Amsterdam.

XII.

THE VIRGIN, INFANT SAVIOUR, ST. JOHN, JOSEPH, AND ELIZABETH—-Study for the picture in the Munich Gallery—on blue paper, heightened with white.

Size, 11 in. by 10⅓ in. From the Collection of the Count Gelosi.

XIII.

THE VIRGIN, THE INFANT SAVIOUR, AND ST. JOHN—a beautiful design for a Holy Family; the Virgin holds a book, which is regarded with attention by the Saviour. Though sketched with a pen, and slight in execution, the characters, particularly of the Christ, are wonderful.

Size, 9 in. by 6¼ in. From the Collections of T. Della Vite and the Marquis Antaldi.

XIV.

SPORTING BOYS—and other designs. Executed by Raffaelle, when employed in the Arabesque ornaments of the Vatican. Nothing can exceed the expression of this very capital Study. It is executed with the pen.

Size, 11 in. by 8 in. From the Collection of W. Y. Ottley, Esq.

XV.

STUDY OF THE ANGEL—over one of the constellations, for the Mosaic in the Chiesa di Santa Maria, near the Porta del Popolo, at Rome; red chalk.

Size, 7¾ in. by 6¾ in. From the Collection of the Chevalier Vicar.

XVI.

THE SAVIOUR AND APOSTLES AT SUPPER—finished drawing, bistre, heightened with white.

Size, 10⅜ in. by 7 in. From the Collection of the Chevalier Vicar.

XVII.

STUDY FOR TOBIT AND THE ANGEL—partaking much of the Perugino style, on a prepared paper with a metal point heightened with white.

Size, 9½ in. by 7⅜ in. From the Collection of the Chevalier Vicar.

XVIII.

NYMPHS AND TRITONS—design for a chased silver dish; admirably drawn with the pen, in his finest manner.

Size, 14½ in. by 9 in. From the Collection of the Chevalier Vicar.

XIX.

MARINE MONSTERS—executed with the pen.

Size, 16 in. by 9½ in. From the Collections of the Chevalier Vicar, and W. Y. Ottley, Esq.

XX.

THE VIRGIN, THE INFANT CHRIST, AND ST. JOHN—for the Picture at Vienna, called " The Madonna of the Belvedere." The figures unclothed, the St. John very slightly marked in. The Virgin is seated, and the most finished of the three figures, in bistre wash. Behind is a sketch in red chalk, of the drapery intended for the Virgin.

Size, 8½ in. by 7 in. From the Collection of the Marquis Antaldi.

.XXI.

A FEMALE—with a vase on her shoulder, and another assisting a Faun in lifting a weight on his shoulder. This drawing is sketched with the pen and bistre ; the figures are most correctly drawn, and are unclothed.

Size, 11 in. by 8¼ in. From the Collection of Count Baglione of Perugia.

XXII.

THE SARACENS AT OSTIA—spirited pen drawing representing fighting men undraped. A Study for the Vatican Fresco painting.

XXIII.

On the reverse of the above is another sketch for the same Painting—equally fine.

Size, 15½ in. by 10¾ in. From the Collections of T. Della Vite, Crozat, Mariette, and Brunet.

XXIV.

THE ANGEL APPEARING TO THE SHEPHERDS—pen and bistre wash.

Size, 12¾ in. by 11 in. From the Collection of the Marquis Legoy.

XXV.

A Sheet of Studies—for the Entombment of our Lord. At the lower part are two of the Apostles laying out the Body, and above are four heads and a hand, which form part of this magnificent work. It is executed with the pen and bistre.

Size, 12½ in. by 8¾ in. From the Collections of T. Della Vite, M. Bordage, Crozat, and B. Constantine.

XXVI.

The Arrival of the Cardinal de Medici (Leo X.) at Rome—attended by other dignitaries of the Church. The rivers Tiber and Arno are symbolically represented. This splendid drawing is most carefully executed with a pen, washed with bistre, and heightened with white, and was painted in Fresco in the Vatican.

Size, 11 in. by 9¼ in. From the Collections of M. Zanetti, and the Baron de Non.

XXVII.

Hercules—*Gaulois,* or Eloquence. *Copied in the Cabinet du Roi.* Highly finished in bistre, heightened with white. One of the most important drawings of this great Master.

Size, 9¼ in. by 9¾ in. From the Collections of T. Della Vite, Marquis Antaldi, M. Crozat, Marquis Legoy, and Thomas Dimsdale, Esq.

XXVIII.

Study of a Soldier lying down—from one of the subjects of the history of Constantine in the Vatican; black chalk.

Size, 12½ in. by 7¼ in. From the Collection of Sir P. Lely.

XXIX.

The Study of Adam—in the act of receiving the forbidden fruit from Eve, for the subject of the famous engraving by M. Antonio Raimondi. Freely sketched with the pen and bistre.

Size, 13 in. by 10½ in. From the Collections of Crozat, Mariette, and H Fuseli, Esq.

XXX.

MINERVA AND OTHER FIGURES—as Statues; in compartments, arched at top. Finished with the metal point, on prepared paper, and heightened with white. A Study for part of the background for the Fresco painting of the School of Athens in the Vatican.

Size, 10¾ in. by 8 in. From the Collections of the Chevalier Vicar and W. Y. Ottley, Esq.

XXXI.

STUDY—for two of the figures on the steps in the School of Athens; also the head of Medusa, introduced on the shield of Minerva, in the same work. Carefully drawn with the metal point, heightened with white, on a prepared paper.

Size, 11¼ in. by 8 in. From the Collections of the Chevalier Vicar and W. Y. Ottley, Esq.

XXXII.

STUDIES OF SEVERAL FIGURES— Archimedes and his Scholars, for the painting of the School of Athens. Drawn on a prepared ground with a metal point.

Size, 12⅞ in. by 9¼ in. From the Collection of W. Y. Ottley, Esq.

XXXIII.

WARRIORS FIGHTING—five figures, in red chalk; a Study for one of the basso-relievos in the School of Athens.

Size, 15 in. by 11 in. From the Collections of the Chevalier Vicar and W. Y. Ottley, Esq.

XXXIV.

DRAWING OF THE BACKGROUND FOR THE PAINTING OF THE SCHOOL OF ATHENS —pen worked with bistre.

Size, 9 in. by 5⅞ in. From the ancient Collection of the Earl of Arundel.

XXXV.

STUDY FOR THE FRESCO OF THE FINDING OF MOSES—in the Loggia of the Vatican: bistre, heightened.

Size, 10⅜ in. by 9½ in. From the Collection of the Duke of Alva.

XXXVI.

THE VIRGIN AND THE APOSTLES—mourning over the dead Body of our Lord; the three Maries and other figures attending. Ten figures, drawn with the pen and bistre; in the second time of this great Master. Very fine. An idea for the celebrated Borghese picture of the Entombing of Christ.

Size, 8¼ in. by 7¼ in. From the Collection of the Baron de Non, of Paris.

XXXVII.

BATTLE FOR THE STANDARD—figures unclothed; supposed to have been drawn in 1507-8. Pen drawing.

Size, 16 in. by 11 in. From the Collections of the Marquis Antaldi and W. Y. Ottley, Esq.

XXXVIII.

DAVID GIVING HIS LAST CHARGE TO SOLOMON—(1 Kings, ii. 3.) A fine composition. Pen drawing.

Size, 10⅜ in. by 7⅜ in. From the Collection of Thomas Dimsdale, Esq.

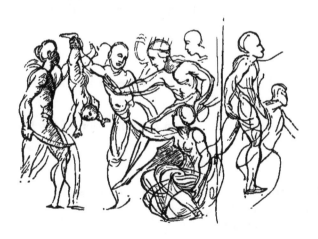

XXXIX.

A SMALL STUDY—of the Judgment of Solomon. Painted in *grisaille,* in the Vatican, on a prepared ground with a metal point. Roman, 1508-1513.

Size, 5⅜ in. by 4 in. From the Collection of the Marquis Antaldi.

STUDIES BY RAFFAELLE.

SECOND SERIES.

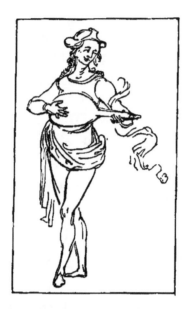

A graceful Study of a young man playing a guitar. Pen.
From the Collection of the Marquis Antaldi.

I.

STUDY FOR A ST. CATHARINE—in black chalk, in his earliest
manner.

Size, 14⅞ in. by 11 in. From the Collection of the Marquis Antaldi.

II.

STUDIES OF SMALL FIGURES OF THE HOLY FAMILY, &c.—
and also of a Church for a background. A pen Drawing, *with the
autograph of Raffaelle.* 1501.

Size, 10½ in. by 8⅞ in. From the Collection of the Marquis Antaldi.

III.

STUDY, TWO FIGURES—Soldier sitting on his Shield, &c. Drawn on a prepared ground with a metal point.

Size, 12⅝ in. by 8⅞ in. From the Collection of the Duke of Alva.

IV.

TWO YOUNG MEN—one lying on the ground. Silver point, heightened.

Size, 13 in. by 9¼ in. From the Collection of the Duke of Alva.

V.

STUDY FOR A GROUP OF MILITARY FIGURES—being for part of the Frescoes painted, 1502-4, by Pinturichio, in the Library of the Duomo at Sienna, sketched with a metal point on grey paper.

Size, 9 in. by 8¾ in. From the Collection of W. Y. Ottley, Esq.

VI.

A YOUTH ON HIS KNEES—probably intended for St. Stephen. 1506.

Size, 10¼ in by 7¼ in. From the Collection of W. Y. Ottley, Esq.

VII.

STUDY—of a Soldier in the Resurrection; also a Study for the Almighty, with two Cherubim for the Cupola, in the Church of Santa Maria, Porta del Popolo.

Size, 8⅝ in. by 8⅝ in. From the Collection of the Chevalier Vicar.

VIII.

LANDSCAPE—with a view of a city. Pen.

Size, 9¼ in. by 6½ in. From the Collection of Mons. Crozat.

IX.

A STUDY OF ELEPHANTS—red chalk.

Size, 12¼ in. by 8¼ in. From the Collection of the Chevalier Vicar, of Rome.

X.

FIGHTING FIGURES—or probably a design for Warriors in the Rape of Helen. Pen.

> Size, 16¼ in. by 10 in.　From the Collection of M. Verstegh.

XI.

A STORM—Saints praying in a Boat.　Bistre wash.

> Size, 5 in. by 4½ in.　From the Collections of Mr. Richardson and Sir Joshua Reynolds.

XII.

CHARITY—a female and three naked children.　This very capital Design is executed in black chalk, at the best time of this illustrious Master—first period.

> Size, 12¼ in. by 6 in.　From the Collections of M. de Rover and M. Revil.

XIII.

JACOB WRESTLING WITH THE ANGEL—bistre, heightened with white.

> Size, 16⅛ in. by 5¾ in.　From the Collection of the Duke of Alva.

XIV.

JACOB AND REBECCA PREPARING THE SAVOURY MEATS—arched top, as if intended for one of the Vatican Frescoes. Washed with bistre and heightened with white.　1507.

> Size, 10⅛ in. by 5 in.　From the Collection of the Duke of Alva.

XV.

ABRAHAM OFFERING UP ISAAC—bistre, heightened with white.

> Size, 12½ in. by 8⅜ in.　From the Collection of the Duke of Modena.

XVI.

MOSES STRIKING THE ROCK—Study for one of the Fresco Paintings in the Loggia of the Vatican.　A fine composition, drawn in bistre and heightened with white.

> Size, 11¼ in. by 9 in.　From the Collection of the Chevalier Vicar.

XVII.

THE SALUTATION OF THE VIRGIN—a finished composition, grey colour, heightened with white. Engraved by Caraglio.

Size, 12¾ in. by 8¼ in. From the Collection of the Marquis Legoy.

XVIII.

THE ADORATION OF THE MAGI — drawn in bistre and heightened with white.

Size, 12¼ in. by 8⅓ in. From the Collection of J. Harman, Esq.

XIX.

THE ADORATION OF THE MAGI—the centre portion of the large tapestry in the Vatican. In bistre, heightened with white. 1518.

Size, 15¾ in. by 9⅜ in. From the Collection of R. Udney, Esq.

XX.

A HOLY FAMILY—and Adoration of the Shepherds. Twelve Figures drawn with the pen.

Size, 15½ in. by 10½ in. From the Collections of the Chevalier Vicar and W. Y. Ottley, Esq.

XXI.

A SKETCH FOR A PICTURE OF THE MADONNA AND INFANT SAVIOUR. With the pen.

From the Collection of the Duke of Alva.

XXII.

VIRGIN AND CHILD. 1503.

XXII*.

THE VIRGIN SEATED, WITH A BOOK. 1505.

Size, 8¼ in. by 5⅛ in. From the Collection of the Marquis Antaldi.

XXIII.

THE VIRGIN EMBRACING THE INFANT SAVIOUR—a most graceful and beautiful composition, engraved by Marc Antonio.

Size, 6¾ in. by 5⅛ in. From the Collection of the Marquis Legoy.

XXIV.

STUDY—in red chalk, for the head of St. Elisabeth in the Picture called the Perla, now in Madrid.

Size, 9⅝ in. by 7⅓ in. From the Collection of the Chevalier Vicar.

XXV.

OUR LORD CROWNING THE VIRGIN. 1516.

Size, 13¾ in. by 11½ in. From the Collections of Mariette, M. Bordage, and Lempereur.

XXVI.

THE VIRGIN AND THE APOSTLES MOURNING OVER THE BODY OF OUR LORD.

Size, 12¾ in. by 9½ in. From the Collection of King Charles the First.

XXVII.

STUDY—of three figures for the celebrated Borghese Picture representing the Saviour carried to His tomb. This Study is most interesting, as proving the care of this illustrious Master in preparing for his pictures. The figures in the present drawing are unclothed, to mark the anatomy; the Body of our Lord is slightly indicated in red chalk. It is executed with the pen and bistre. 1508.

Size, 11¼ in. by 9¾ in. From the Collections of T. Della Vite and the Marquis Antaldi.

XXVIII.

ONE OF THE ABOVE FIGURES—with variations.

XXIX.

STUDY—called the Death of Adonis; evidently a design for the entombment, reversed.

Size, 13 in. by 10¼ in. From the Collections of Crozat, Mariette, and H. Fuseli, Esq.

XXX.

THE MIRACULOUS DRAUGHT OF FISHES—washed with bistre.

Size, 13⅝ in. by 6⅓ in. From the Collection of the Duke of Alva.

XXXI.

A FEMALE FIGURE—in the Vatican Fresco-painting, of Heliodorus driven from the Temple.

XXXII.

On the reverse, another Study—Female with Two Children, for the Heliodorus. Black chalk.

From the Collection of Sir Joshua Reynolds.

XXXIII.

HEAD OF THE HORSE OF HELIODORUS.—This admirable cartoon is inestimable. Mr. Ottley, in the School of Design, thus describes it:—" The head of the horse, which was formerly preserved in the Albani Palace at Rome, is of such marvellous perfection, that it can only be compared to the finest remains of ancient Greek art."

Size, 27 in. by 21 in. From the Collections of the Cardinal Albani and W. Y. Ottley, Esq.

XXXIV.

A DRAPED FEMALE FIGURE AS A CARYATIDE—painted in Fresco in the Vatican. One of the Figures dividing the Pictures in the Hall of Heliodorus on grey paper, heightened with white.

Size, 14⅝ in. by 6⅛ in. From the Collection of Lord Spencer.

XXXV.

THE RESURRECTION OF OUR SAVIOUR—washed in bistre, heightened with white.

Size, 20½ in. by 12¼ in. From the Collection of the Chevalier Vicar.

XXXVI.

A SHEET OF STUDIES—chiefly for the picture formerly in the Aldobrandine Palace, late in the Collection of William Beckford, Esq., and now in the National Gallery. This most admirable Study presents the Head of St. Catharine, highly finished with the pen, and also some Studies of Angels.

XXXVII.

On the Reverse are three several Studies of the St. Catharine ---
all varying from the Painting. It is executed with the
pen.

> Size, 11 in. by 7 in. From the Collections of Benjamin West, Esq., President
> of the Royal Academy, and T. Dimsdale, Esq.

XXXVIII.

THE UPPER PART OF THE FRESCO-PAINTING OF THE DISPUTE
ON THE SACRAMENT IN THE VATICAN.—Thirteen figures, ad-
mirably drawn with bistre, heightened with white. 1509.

> Size, 16 in. by $9\frac{1}{4}$ in. From the Collections of Mariette, Marquis Legoy,
> and T. Dimsdale, Esq.

XXXIX.

STUDY OF TWO HEADS FOR THE ABOVE—on a prepared paper
with a metal point.

> Size, $14\frac{7}{8}$ in. by $10\frac{5}{8}$ in. From the Collections of Sir P. Lely and Sir
> Joshua Reynolds.

XL.

THE PRETENDED MIRACLE OF BOLSENA.—It is a pen Draw-
ing in bistre, worked with Indian ink.

> Size, $16\frac{1}{4}$ in. by $10\frac{1}{5}$ in. From the Collection of Sir Joshua Reynolds.

XLI.

THE MOUNT PARNASSUS—the first Design for this celebrated
Fresco in the Vatican. Executed with the pen, figures unclothed.
1510.

> Size, $18\frac{3}{4}$ in. by 12 in. From the Collection of the Chevalier Vicar.

XLII.

MELPOMENE—a Study for one of the figures in the Fresco of
the Vatican ; *Mount Parnassus.*

> Size, $13\frac{1}{4}$ in. by 10 in. From the Collection of W. Y. Ottley, Esq.

XLIII.

CASSANDRA, OR A MUSE.

> Size, $8\frac{1}{4}$ in. by $5\frac{7}{8}$ in. From the Collection of the Marquis Antaldi.

XLIV.

STUDY FOR TWO SONNETS.

XLV.

THE SUSPENDED MAN—endeavouring to escape from the fire. A fine model, evidently from the life, for the celebrated Fresco the *Incendio del Borgo* in the Vatican. This splendid Study is executed with a bold pencil and bistre, heightened with white.

Size, 16¼ in. by 9¼ in. From the Collection of the Baron de Non.

XLVI.

THE FEMALE CARRYING TWO VASES, WITH WATER—in the celebrated Fresco of the *Incendio del Borgo* in the Vatican. Carefully drawn with the pen and bistre, heightened with white: in the manner of M. Angelo.

Size, 15½ in. by 6¼ in. From the Collections of Dr. Mead, A. Pond, Esq., and T. Dimsdale, Esq.

XLVII.

A WARRIOR STRIDING OVER A FALLEN FOE.—Black chalk.

Size, 15½ in. by 10¾ in. From the Collection of M. Dargenville.

XLVIII.

SAMSON BREAKING THE JAWS OF THE LION—a Study with the pen, full of expression, and in surprising preservation, in bistre, Roman.

Size, 10½ in. by 10½ in. From the Collection of Prince Borghese, at Rome.

XLIX.

STUDY OF TWO HEADS OF THE APOSTLES—in the centre of the Transfiguration. This is one of the finest Drawings existing by this great Master. In black chalk, heightened with white.

Size, 19¾ in. by 14½ in. From the Collections of M. de Rover of Amsterdam, and J. Harman, Esq.

L.

STUDY OF A FOOT—for one of the figures in the Transfiguration. In black chalk.

E

LI.

STUDY OF FIGURES AND DRAPERY—for St. Michael. Washed in bistre, and heightened with white.

Size, 9¼ in. by 8¼ in. From the Collection of the Marquis Antaldi.

LII.

ONE OF THE SIBYLS—in the celebrated Fresco of the Chiesa della Pace at Rome. A most splendid and elegant figure, executed in red chalk.

Size, 14½ in. by 7½ in. From the Collection of Sir Joshua Reynolds.

LIII.

SEVEN PERSONS SITTING AT TABLE. Sketched with the metal point, and heightened with white, on a prepared paper; full of expression.

LIV.

STUDIES OF NUDE FIGURES—one of them à Man holding a Book and Sword, probably a preliminary for St. Paul. A pen Drawing in bistre.

LV.

On the reverse, another Drawing in the finest time of Raffaelle.

Size, 10½ in. by 7½ in. From the Collection of Mons. Brunet.

LVI.

STUDIES OF FOUR FIGURES OF WARRIORS.—Pen Drawing.

Size, 10⅞ in. by 8⅝ in. From the Collection of Mr. Berwick.

LVII.

THREE MUSICIANS—a draped female touching the harp, and two undraped men, one playing a small violin, the other blowing a sort of wind-instrument, sketched with pen and bistre.

LVIII.

STUDY OF A MAN—also a Female Head. Pen.

Size, 9⅞ in. by 8⅛ in. From the Collection of the Duke of Alva.

ADORATION OF THE SHEPHERDS. 1505.

From Chambers Hall's Collection.

LX.

PRESENTATION IN THE TEMPLE. A very early pen Drawing.
1504.

From Chambers Hall's Collection.

LXI.

THE INFANT SAVIOUR—Bel Jardinière.

From Chambers Hall's Collection.

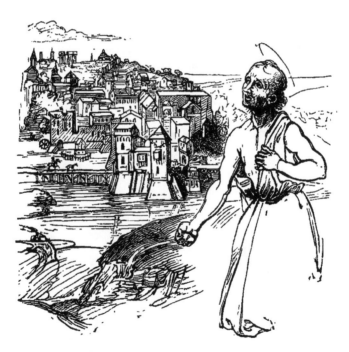

A Saint on his knees—distance, View of a City like Perugia.
From the Collection of the Marquis Antaldi.

CHISWICK PRESS:—PRINTED BY WHITTINGHAM AND WILKINS,
TOOKS COURT, CHANCERY LANE.

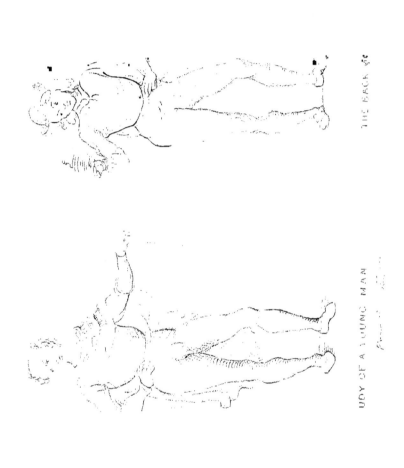

BODY OF A YOUNG MAN

THE BACK

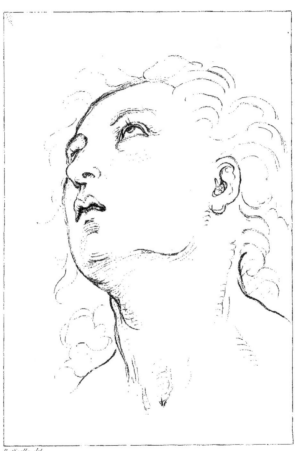

Raffael

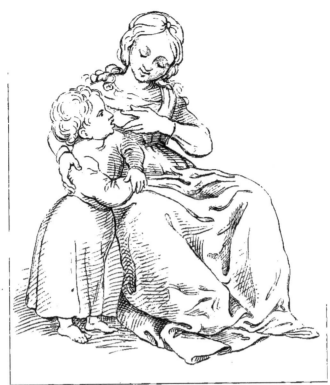

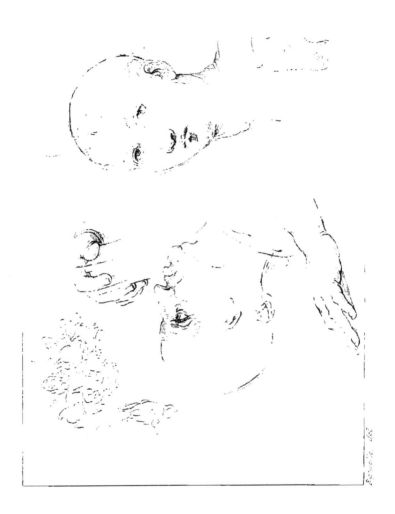

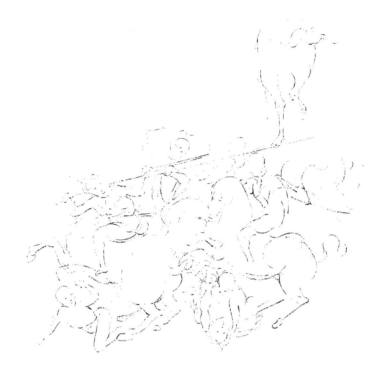

The Battle of the ... Mounted Fighting on the Standard.
... Florence A.D. 1500.

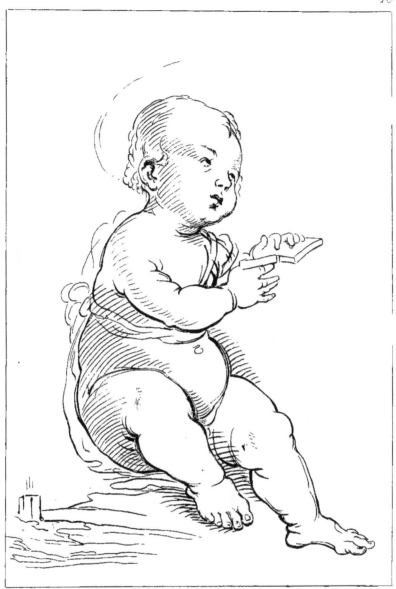

Rafaelle del.

STUDY FOR THE INFANT SAVIOUR.

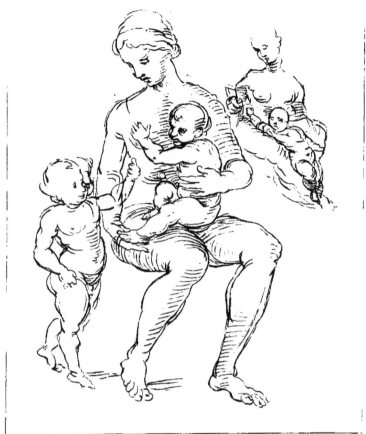

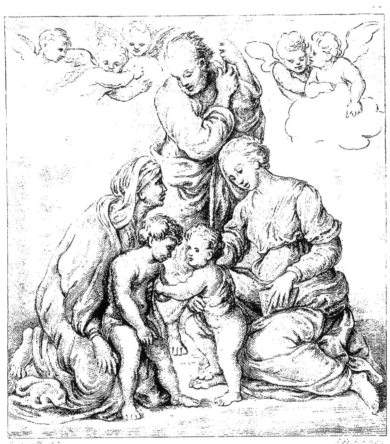

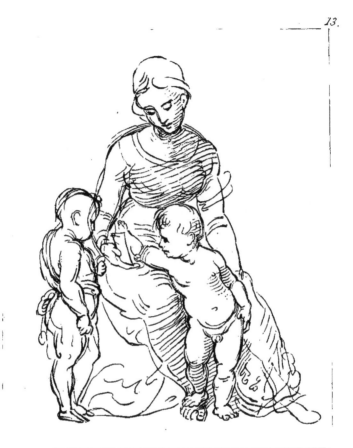

Raffaelle del. J. Fisher fec.

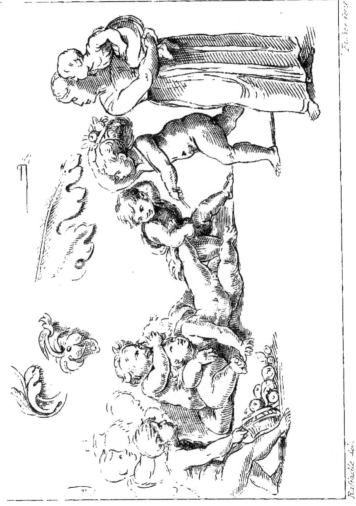

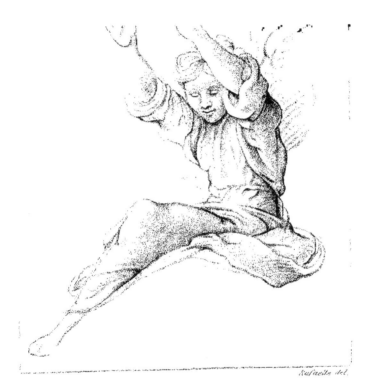

Raffaello del.

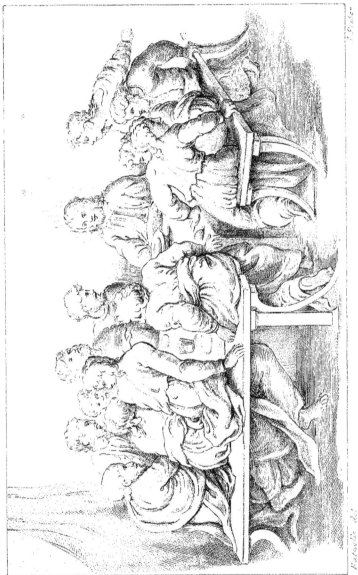

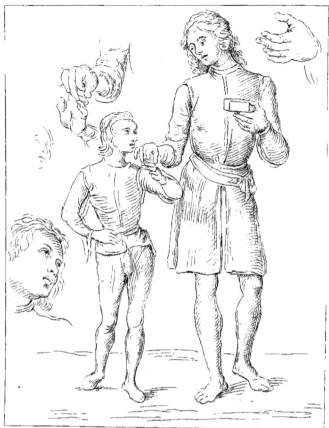

Raffaelle del.

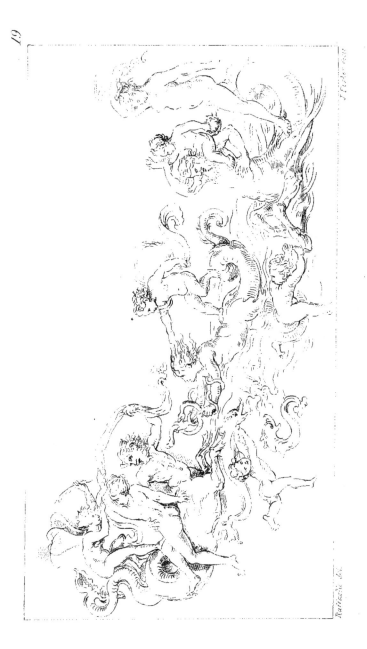

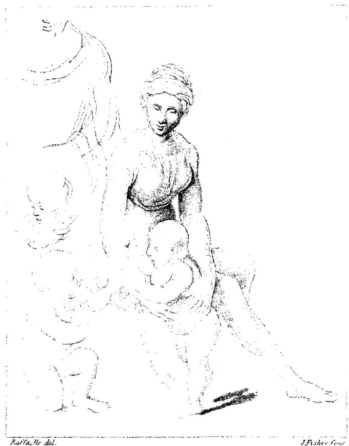

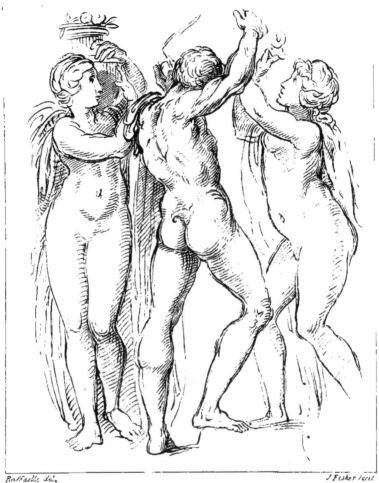

Raffaellis del. J Fisher fecit

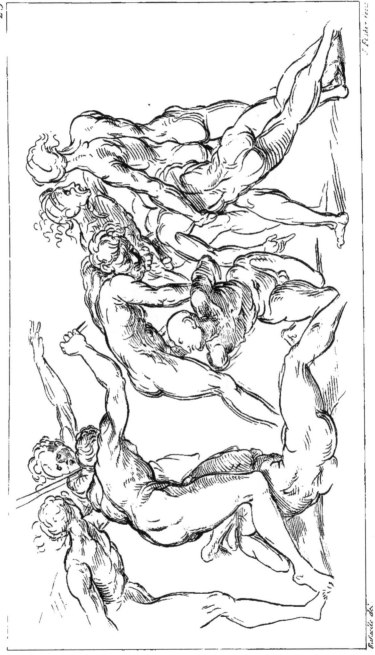

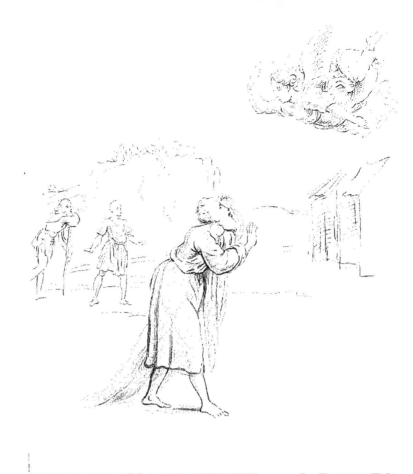

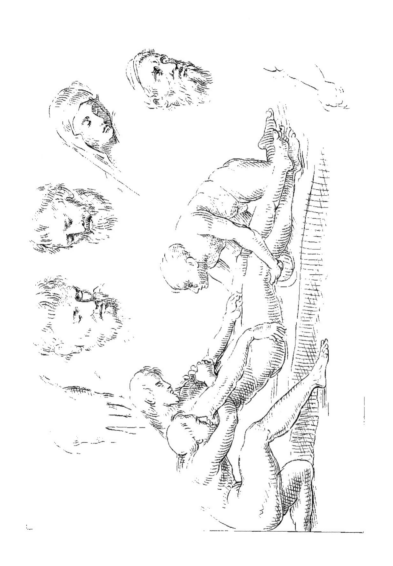

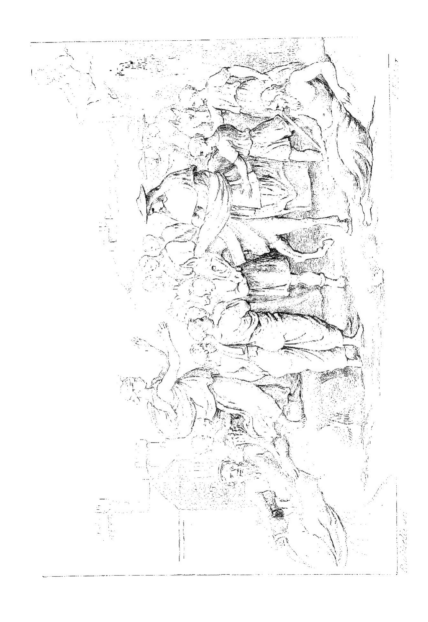

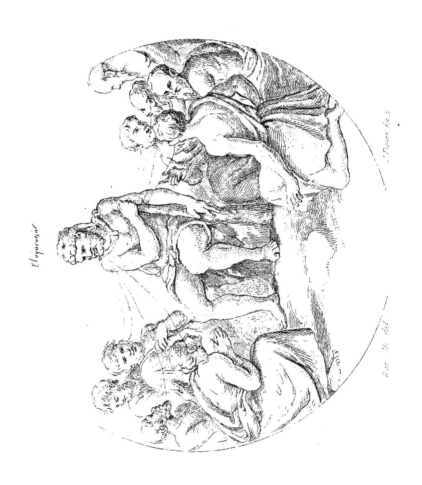

El eloquencia

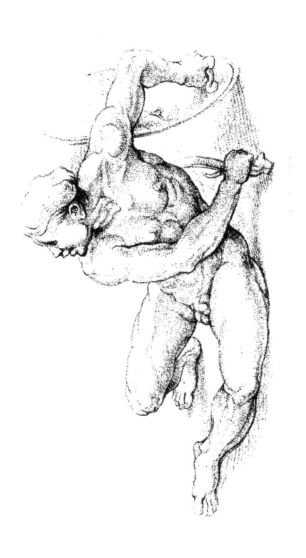

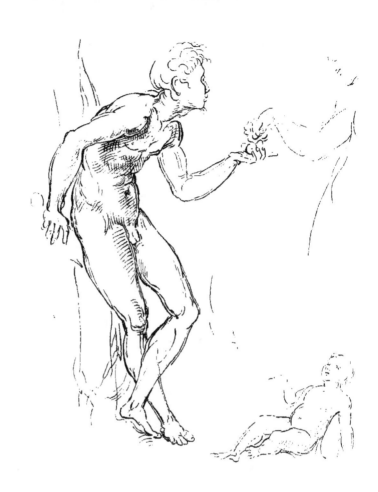

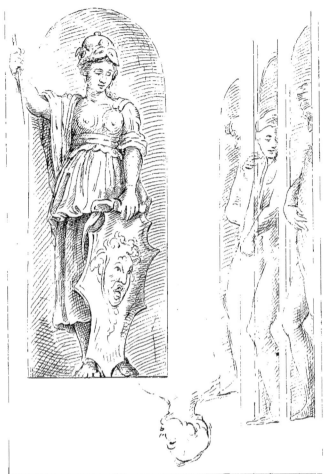

Raffaelle del. J. Fisher sc.

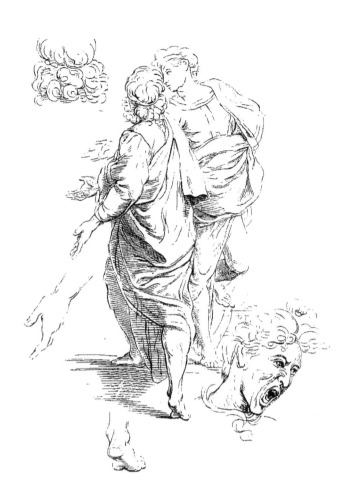

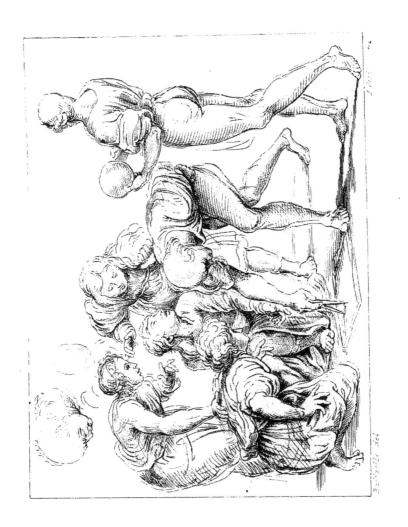

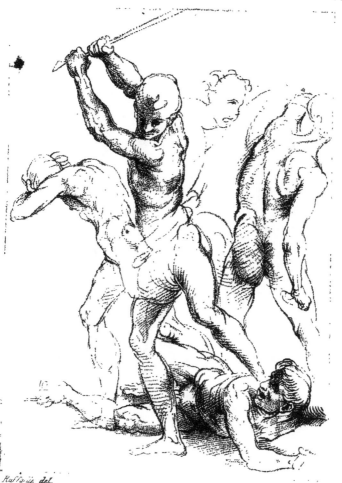

Raffaele del.

J. Fisher fecit

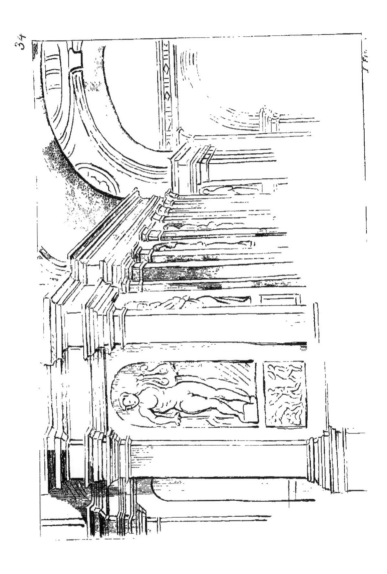

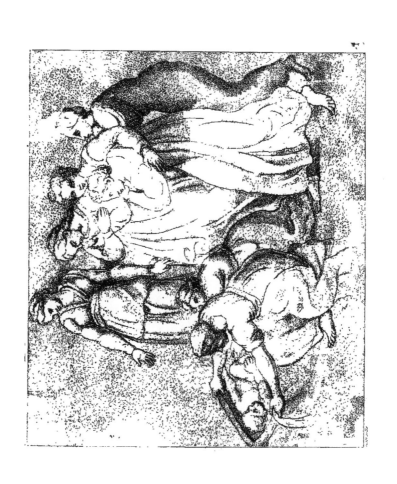

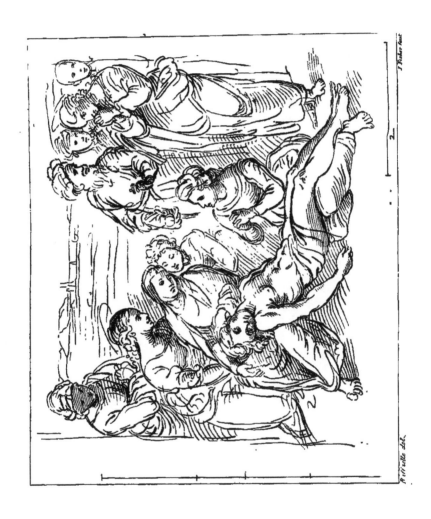

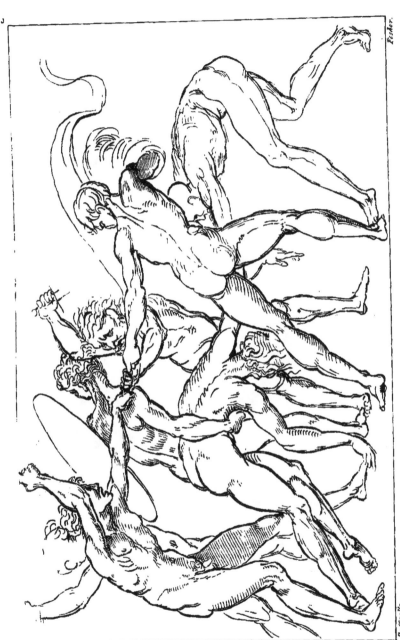

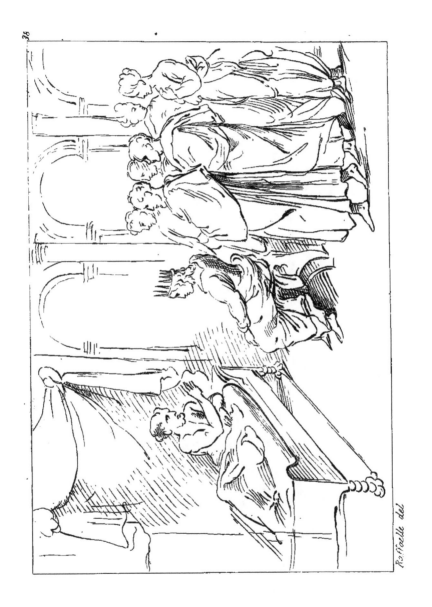

R. Gaille del.

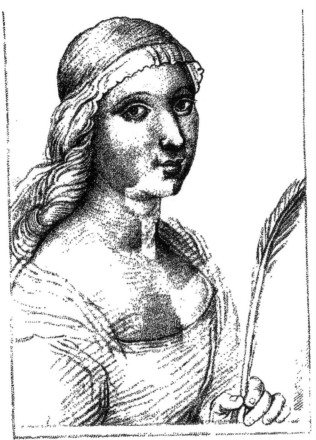

Raffaelle. 1499

STUDY FOR A SAINT CATHERINE

From the Collection of the Marquis Antaldi.

Pl. 2

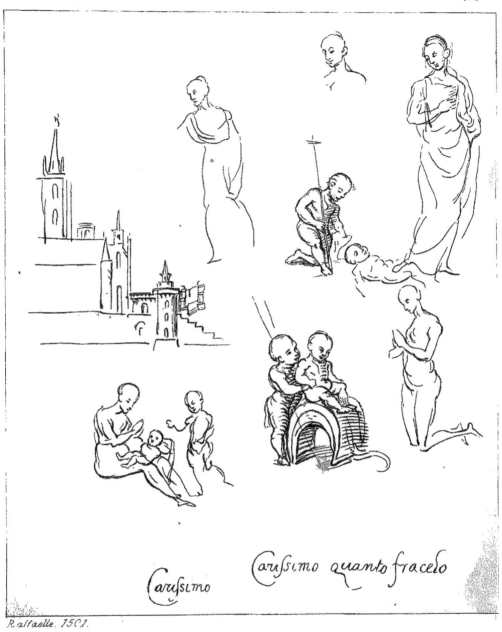

Carıſsımo

Carıſsımo quanto fracelo

Raffaelle. 1501.

STUDIES OF SMALL FIGURES OF THE HOLY FAMILY.— AND ALSO OF A CHURCH.

From the Collection of the Marquis Antaldi.

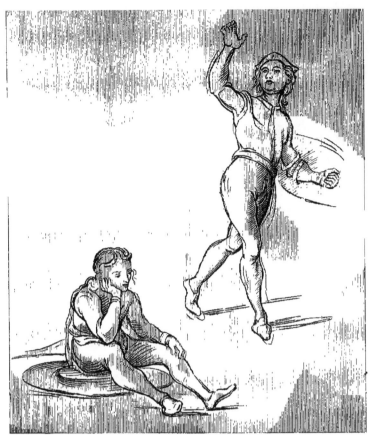

Raffaelle.

TWO SOLDIERS ONE SITTING ON A SHIELD.

From the Collection of the Duke of Alva.

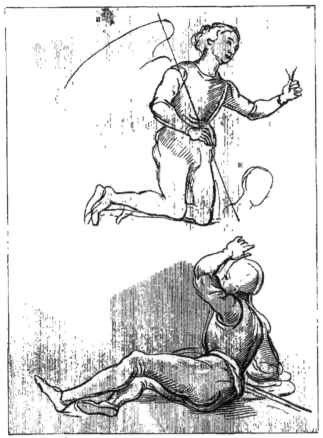

Raffaelle. 1504

TWO YOUNG MEN IN THE PERUGINO MANNER

From the Collection of the Duke of Alva

FOU... ...OURS—FOR PART OF ONE OF THE FRESCOES IN THE LIBRARY OF SIENNA.

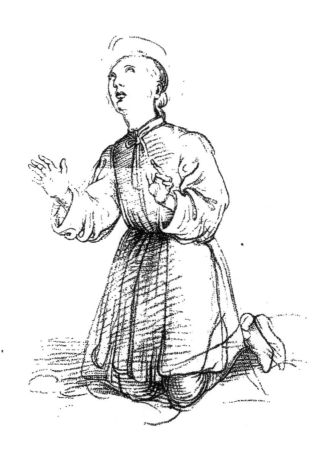

Raffaelle.

A YOUTH ON HIS KNEES PROBABLY INTENDED FOR S^T STEPHEN.

In the Collection of W Y Ottley Esq^r

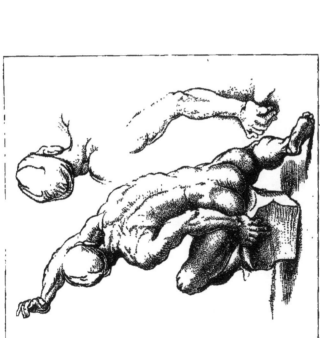

Pl.

STUDY FOR THE ALMIGHTY.

IN THE CHURCH OF SANTA MARIA, ROME.

STUDY — FOR A SOLDIER.

IN THE BOTTOM PART OF THE RESURRECTION

LANDSCAPE WITH A VIEW OF A CITY.

From the Collection of Mons. Crozat.

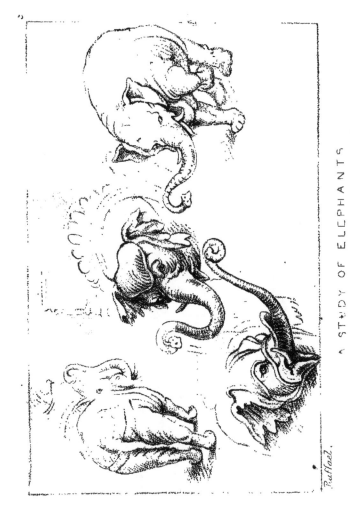

A STUDY OF ELEPHANTS

... of the new Vicar of Rome

Ruffard.

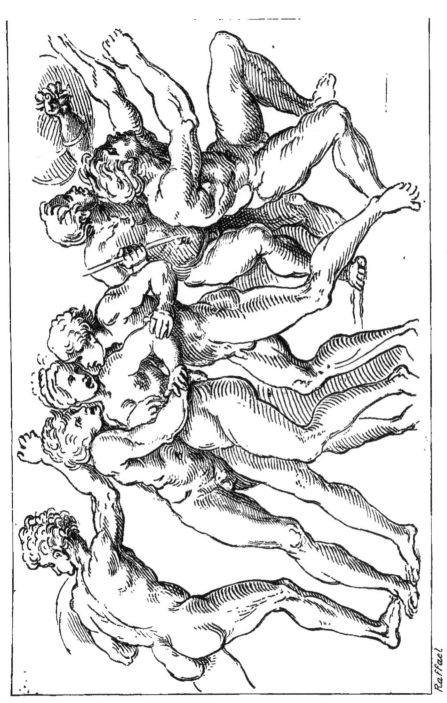

Raffael.

PROBABLY A DESIGN FOR WARRIORS IN THE RAPE OF HELEN.

From the Collection of M Verstegh.

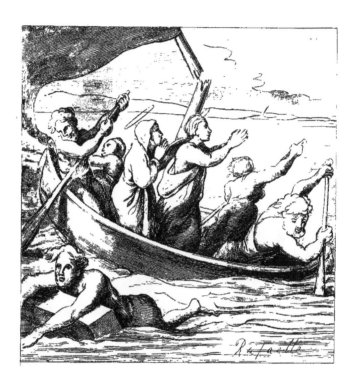

A STORM — SAINTS PRAYING IN A BOAT,

From the Collection of Sir Joshua Reynolds.

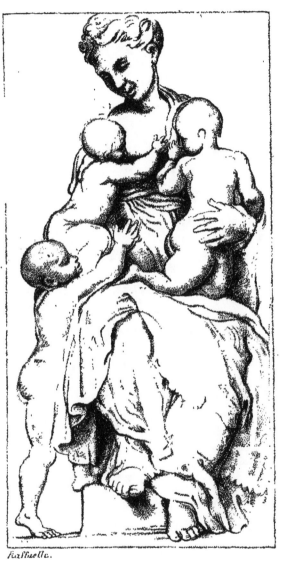

CHARITY.

From the Collections of M. de Rover and M. Revil.

Pl 13

JACOB WRESTLING WITH THE ANGEL.

From the Collection of the Duke of Alva

Rajaelle

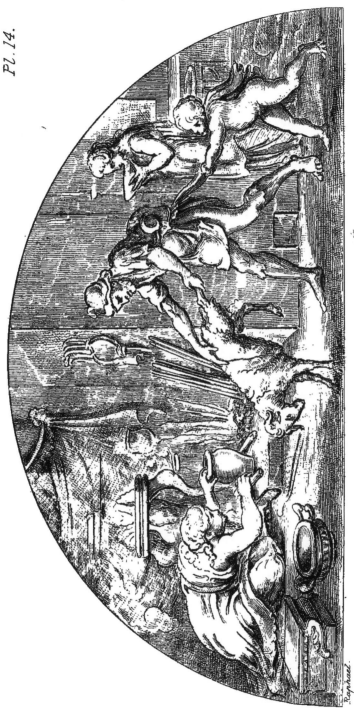

Pl. 14.

PREPARING THE SAVOURY MEATS.

From the Collection of the Duke of Alva

Raphael.

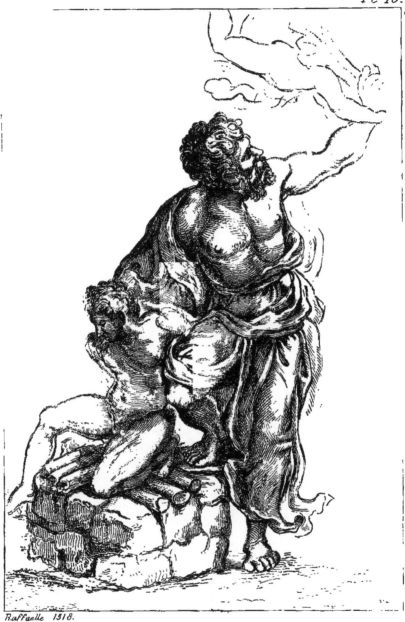

Raffaelle 1518.

ABRAHAMS SACRIFICE.

From the Collection of the Duke of Modena

Pl. 16.

Raffaelle

MOSES STRIKING THE ROCK.

From the Collection of the Chevalier View.

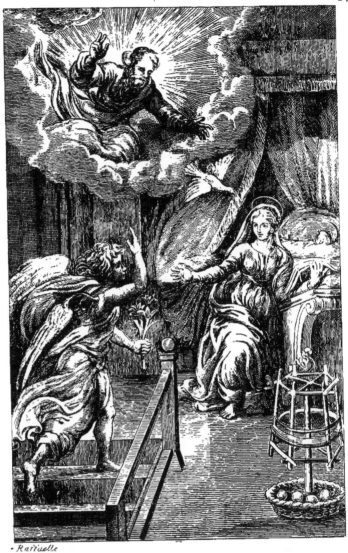

- Raffaelle

THE ANNUNCIATION

From the Collection of the Marquis Antaldi

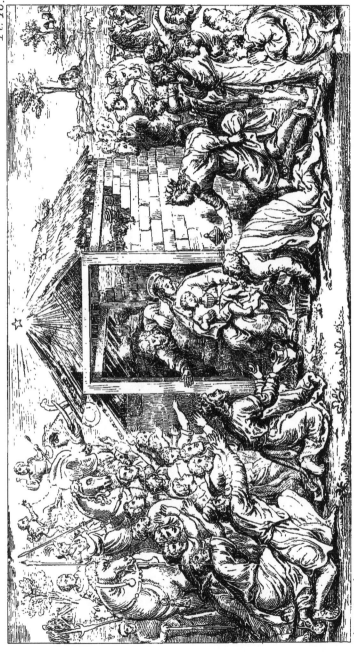

Pl. 18.

Raphael.

THE ADORATION OF THE MAGI.

From the Collection of R. Udney Esq.

Pl 19

Fl 19

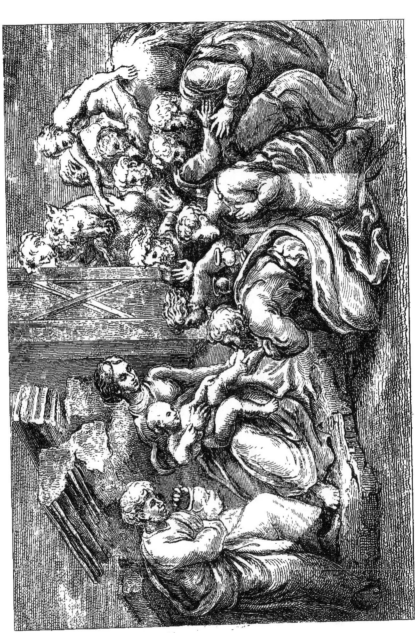

Raffaelle

THE ADORATION OF THE MAGI.

From the Collection of J Harman, Esq.

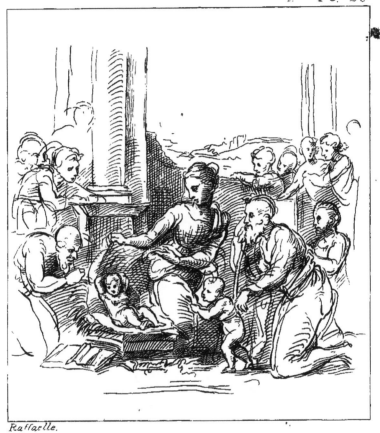

Raffaelle.

A HOLY FAMILY AND ADORATION OF THE SHEPHERDS.

From the Collections of the Chevalier Vicar, and W.Y. Ottley Esq

Pl. 21.

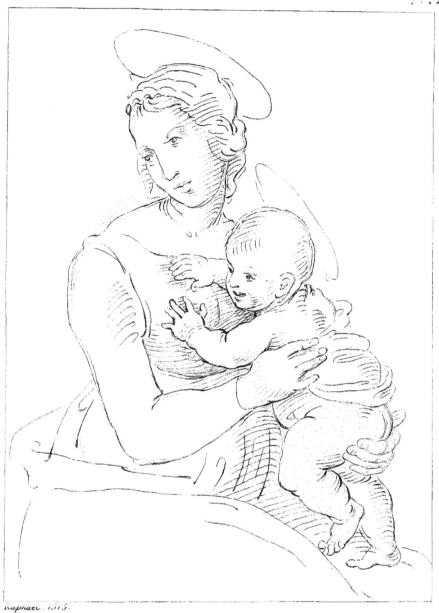

Raphael. 1515.

SKETCH FOR A PICTURE OF THE MADONNA AND INFANT SAVIOUR.
From the Collection of the Duke of Alva.

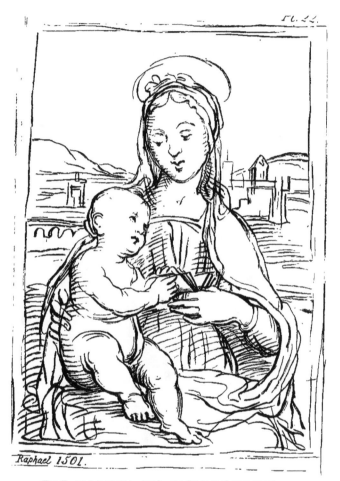

Raphael 1501.

THE MADONNA AND INFANT SAVIOUR.

From the collection of the Marquis Leguy

· Pl. 22 *

Rüffaelle.

THE VIRGIN SEATED STUDYING A BOOK, WITH THE INFANT SAVIOUR,

From the Collection of the Marquis Antaldi.

Pl 23

Raffaelle.

THE VIRGIN EMBRACING THE INFANT SAVIOUR.

From the Collection of the Marquis Legoy.

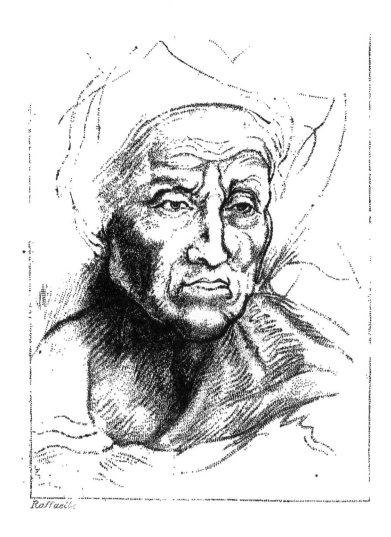

Raffaelle

STUDY FOR THE HEAD OF Sᵗ ELIZABETH IN THE PICTURE CALLED THE PEʳ

From the Collection of the Chev Vicar.

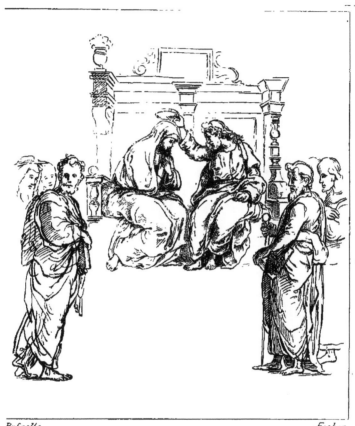

Rafaelle *Fisher*

OUR LORD CROWNING THE VIRGIN.

From the Collection of Mariette.

Pl. 26

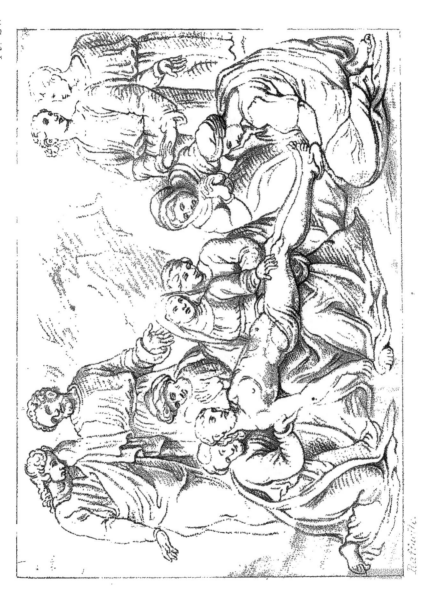

Raphaello.

A COMPOSITION FOR THE ENTOMBMENT OF CHRIST.

From the collection of King Charles the First

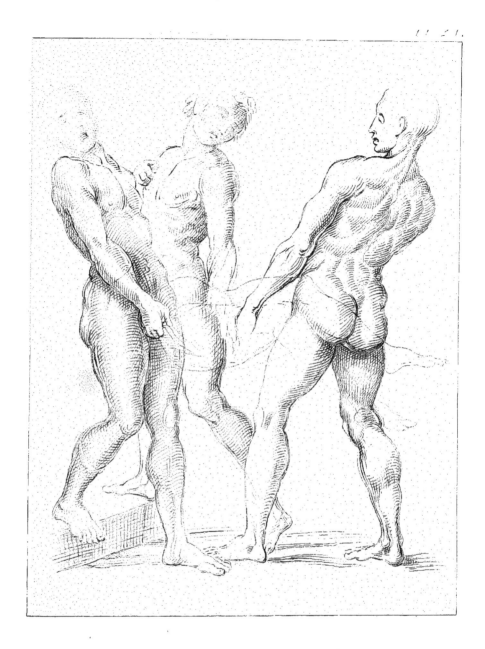

STUDY OF THREE FIGURES FOR THE BORGHESE PICTURE

OF THE ENTOMBMENT.

From the Collections of Tim della Vite, and the Marquis, Antaldi.

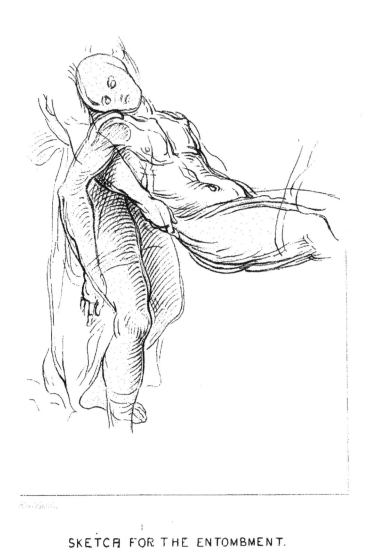

SKETCH FOR THE ENTOMBMENT.

From the Collection of W. Y. Ottley Esq

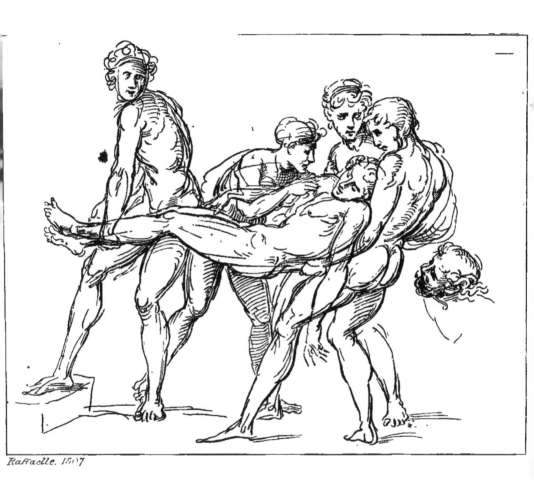

Raffaelle. 1507

STUDY FOR THE ENTOMBMENT OF OUR LORD.

From the Collections of Crozat Mariette, and H Fuseli Esq.

THE MIRACULOUS DRAUGHT OF FISHES.

From the Collection of the Duke of Alva.

Raphael

J. Fisher.

30.
30.

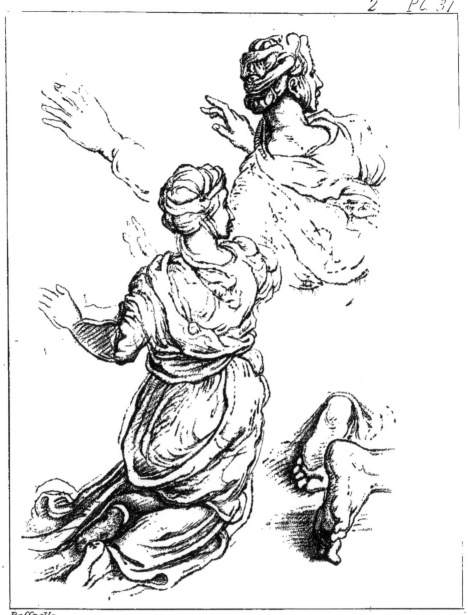

Raffaelle.

STUDY OF A FEMALE IN THE FRESCO OF HELIODORUS DRIVEN OUT OF THE TEMPLE.

From the Collections of Sir Joshua Reynolds, and T. Dimsdale, Esq

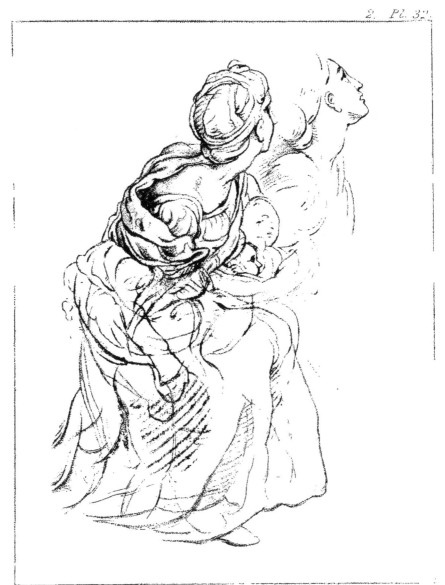

Raffaelle

OY OF A FEMALE WITH TWO CHILDREN HELIODORUS.

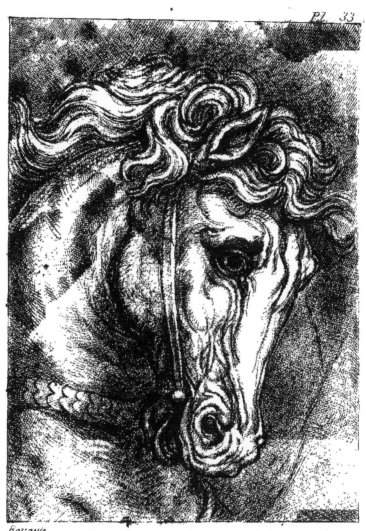

Raffaelle.

PL. 33

HEAD OF THE HORSE — HELIODORUS.

..... the Collections of the Cardinal Albani, and W Y Ottley, Esq

Pl. 34.

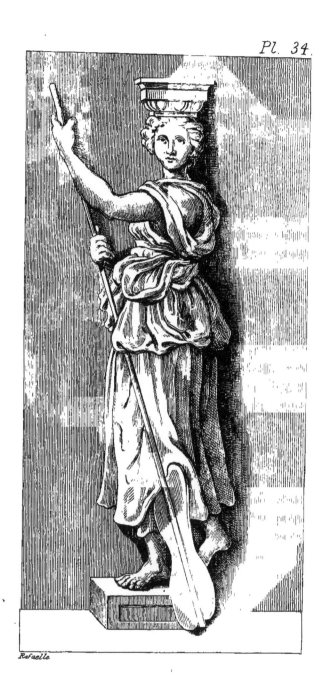

Rafaelle

CARIATIDE—PAINTED IN CAMAIEU IN THE HALL OF HELIODORUS.

From the Collection of Lord Spencer

2 Pl. 35

Raffaelle.

THE RESURRECTION.

From the Collection of the Chevalier Vicar.

Pl. 31

Raffaelle 1506.

STUDY FOR THE HEAD OF S.T CATHERINE (OF ALEXANDRIA) A PICTURE NOW IN THE NATIONAL GALLERY PURCHASED OF M.R BECKFORD FOR £5500.

From the Collection of B. West, F.RS P.P.A.

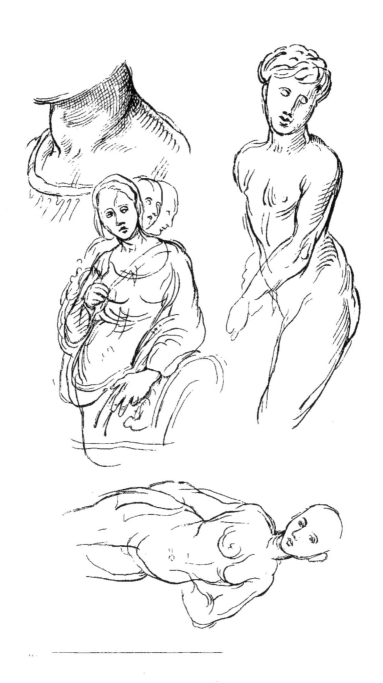

VARIOUS STUDIES FOR THE Sᵗ CATHERINE.

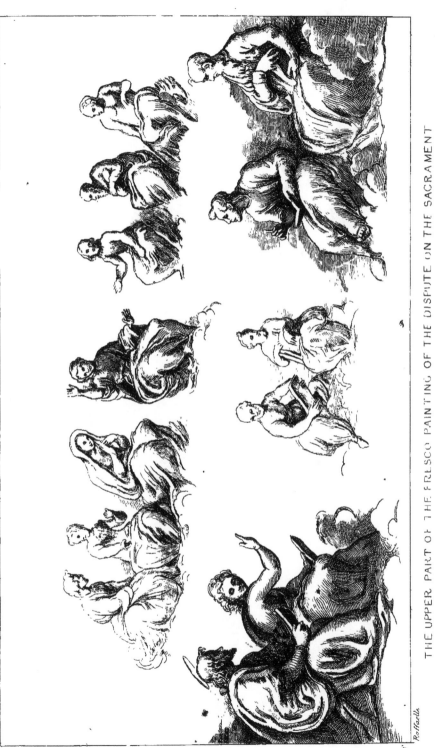

Roffaelli

THE UPPER PART OF THE FRESCO PAINTING OF THE DISPUTE ON THE SACRAMENT

From the Collection of Marietta, Now in possession of T Hemsdale Esq

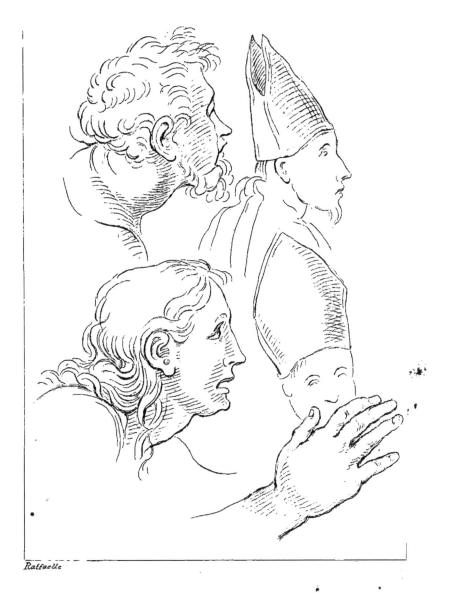

Raffaelle

STUDY OF HEADS FOR THE DISPUTE ON THE SACRAMENT.

From the Collection of the Marquis Antaldi.

THE PRETENDED MIRACLE OF BOLSENA.

Raffaelli

Pl. 41.

R. Noble 1817.

J. Fisher.

THE MOUNT PARNASSUS.

From the Collection of the Chevalier Vicar

Pl. 42.

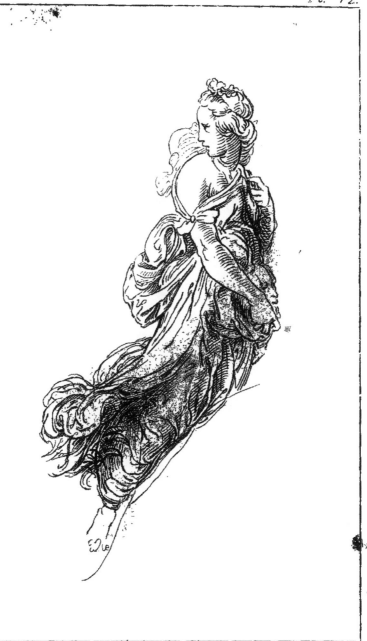

Rafaelle. 1517

MELPOMENE.

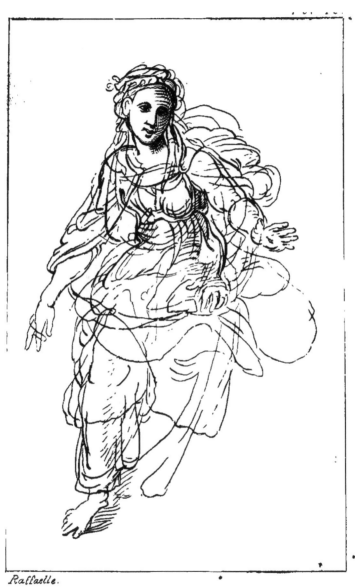

Raffaelle.

CASSANDRA, OR A MUSE

From the Collection of the Marquis Antaldi

Pl. 14.

giace
nnace

dolzefume

podde dir darcoma dei
corro disceso fa del celb
esmo cor duno omoroso xebo
perro tuti spenser mei
chio uiddi eguanto Jo fu
ñdio Faccio che nelpeto telo
rima cempero nel frono elpelo
lobbigo nolga in pensir rei

amor o men nesscalti co dol luce
le doi be hochi diuno mebrugo efaco
labiancha nene edorose nnace
in donessi
da bei parlar ede vnexo coßremi
Torl che tonto ardo olg ne maw nefuumi
Sßegmar potrion quelfocho xerß mfpiaor
ßorchel mio ardor tanto diben vnifate
cardendo pin dalomor pin dardor mecor

Portions of Sonnets in the hand-writing of Raffaelle.

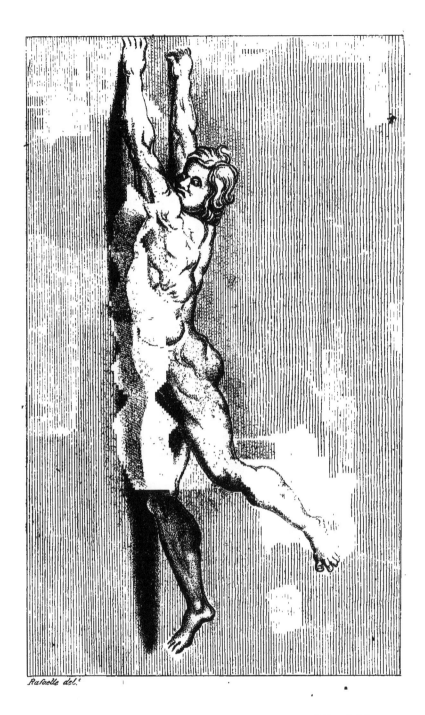

THE SUSPENDED MAN INCENDIO DE'L BORGO.

From the Collection of the Baron Denon.

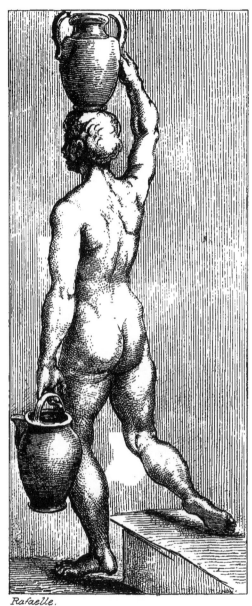

Rafaelle.

STUDY FOR THE FEMALE CARRYING TWO VASES,

IN THE CELEBRATED FRESCO OF THE *INCENDIO DEL BORGO*.

From the Collections of D.ʳ Mead, A. Pond, Esq.ᵉ and T. Dimsdale Esq.ʳ

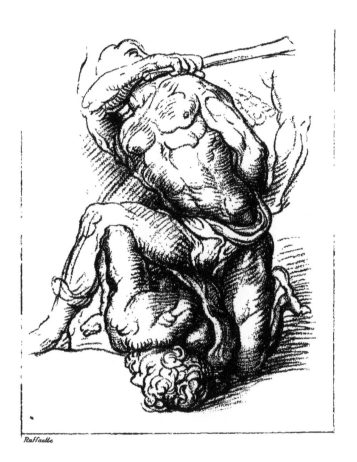

Raffaelle

A WARRIOR STRIDING OVER A FALLEN FOE

From the Collection of M Dargenville.

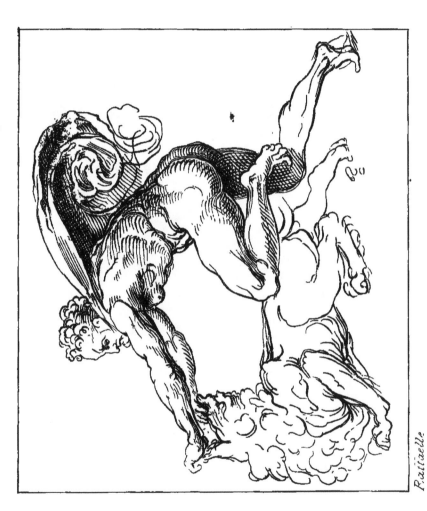

R.Raffaelle

SAMSON BREAKING THE JAWS OF THE LION.

From the Collection of Prince Borghese in Rome

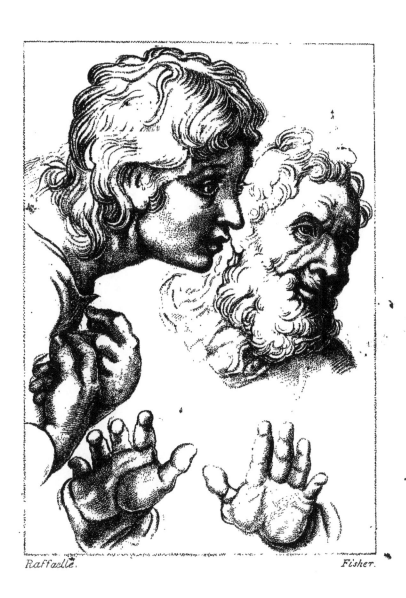

Raffaelle. Fisher.

STUDY OF TWO HEADS OF THE APOSTLES IN THE CENTRE OF THE TRANSFIGURATION

From the Collections of M. de Rover of Amsterdam, and J. Harman, Esq.

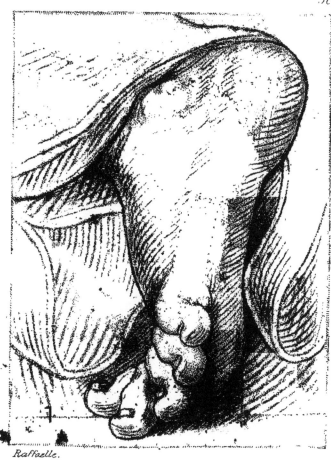

Raffaelle.

STUDY of A FOOT for one of the figures in the TRANSFIGURATION.

From the Collection of the Chevalier Vivas

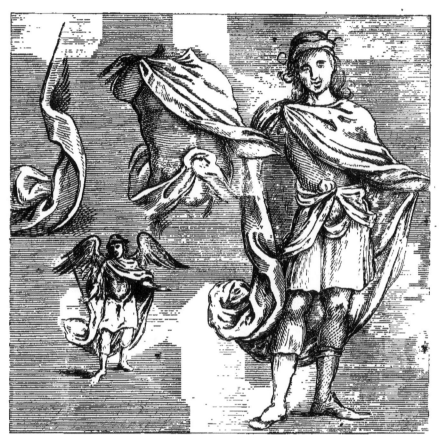

Raffaelle

STUDY OF FIGURES AND DRAPERY FOR S.^t MICHAEL

From the Collection of the Marquis Antaldi.

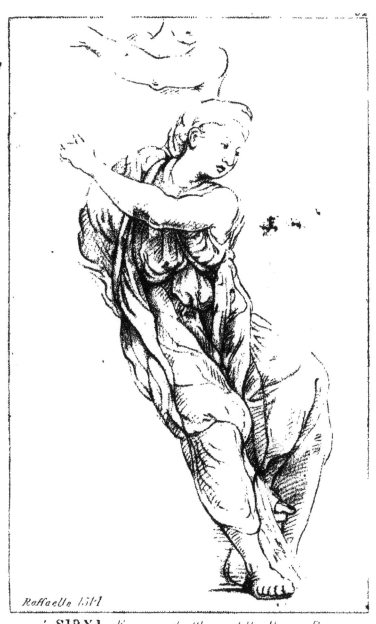

Raffaelle 1514

A SIBYL. Fresco in the Chiesa della Pace. Rome

Pl. 53

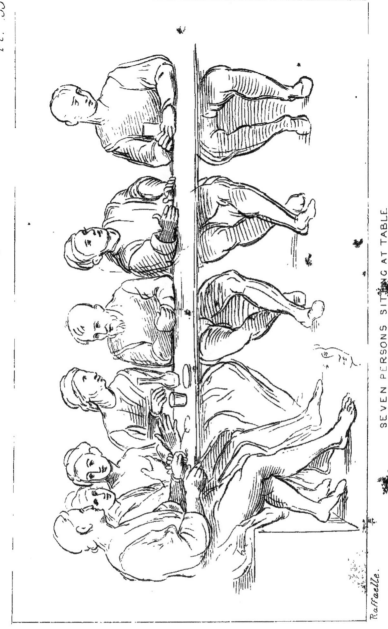

SEVEN PERSONS SITTING AT TABLE

From the Collections of Timothy della Vite and the M. ... Angioli.

Raffaelle.

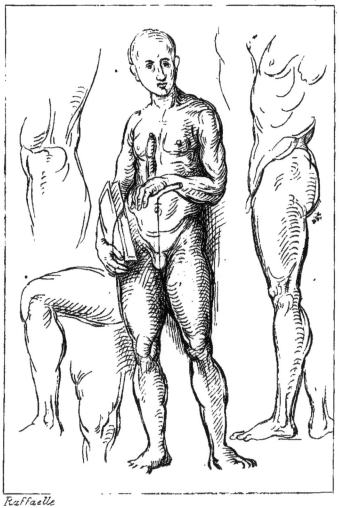

Raffaelle

STUDIES—A MAN HOLDING A BOOK AND SWORD

From the Collection of Mons Brunet

Pl. 55.

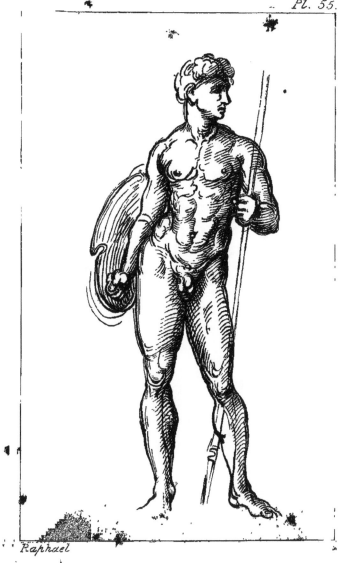

Raphael

STUDY ON THE REVERSE OF THE LAST PLATE

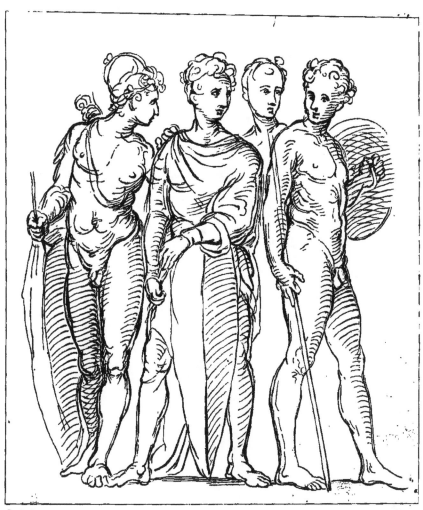

Rafael.

FOUR WARRIORS.

From the Collection of M.ʳ Berwick.

Pl. 31.

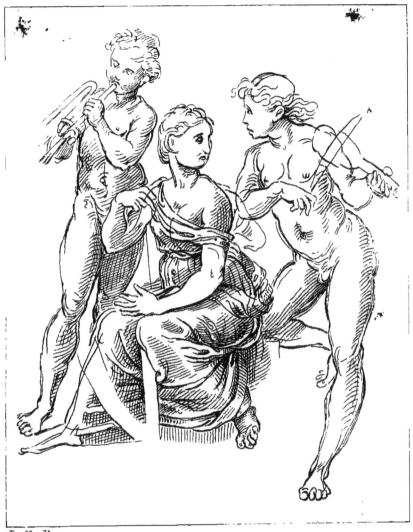

Raffaelle

THREE MUSICIANS A FEMALE TOUCHING THE HARP, AND TWO MEN.

From the Collection of W. Y. Ottley, Esq

CPSIA information can be obtained
at www.ICGtesting.com
Printed in the USA
BVHW041127040219
539410BV00006B/135/P